Everything
You Need to
Know About

Mehndi, Temporary Tattoos, and Other Temporary Body Art

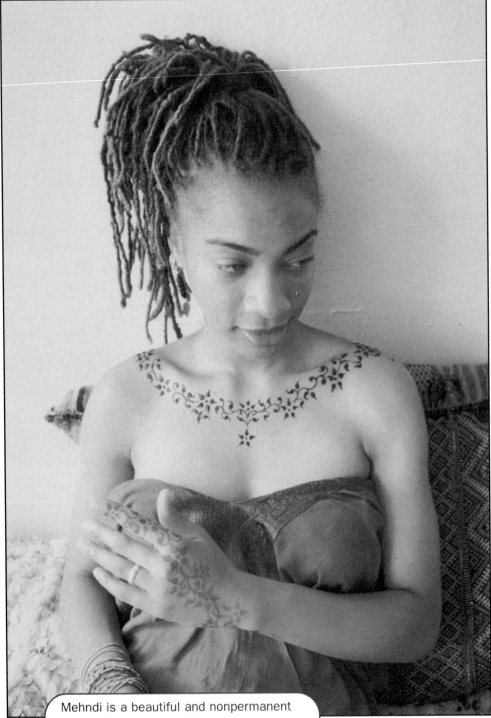

Mehndi is a beautiful and nonpermanent way to decorate your skin.

Everything
You Need to
Know About

Mehndi, Temporary Tattoos, and Other Temporary Body Art

Stefanie Iris Weiss

THE ROSEN PUBLISHING GROUP, INC.
NEW YORK

For my mother, whose shringar has filled my life with constant sweetness and light. I love you.

I'd like to thank all the people who have contributed to the creation of this book. First my brother Hal, who willingly posed for us and supplied me with three lovely Mehndi models: Vanessa Iaffa, Hope Dector, and Michelle Rabinowitz. Thanks also to Kimbi Yates for modeling for the book. Thanks to Stephanie Rudloe, the finest Mehndi artist in New York City, for lending us her talent and time. (Her designs grace these pages). Special thanks to Kiki Tom, photographer and web mistress extraordinaire, for shooting a second book with me. Thanks also to Jivmukti Yoga Center in New York City for letting me observe the mystical Mehndi party that took place in the spring of 1999. And of course, to my loved ones: Dad, Sherene, Liz G., Nance, Jodi, Liz S., Ora, Zig, Jaimie, Missy, Lynn, and Rachelle. And finally, thanks to the women of the East whose divine love and light have inspired the timeless art that is Mehndi.

Published in 2000 by The Rosen Publishing Group, Inc.
29 East 21st Street, New York, NY 10010

First Edition

Library of Congress Cataloging-in-Publication Data

Weiss, Stephanie Iris
 Everything you need to know about mehndi, temporary tattoos, and other temporary body art/ [Stephanie Iris Weiss].
 p. cm.- (The Need to Know Library)
 Includes bibliographical references and index.
 Summary: Discusses the spiritual references and practical applications of mehndi, the practice of painting designs on the body with henna, as well as some of the designs commonly used.
 ISBN 0-8239-3086-6
 1. Mehndi (Body painting) — Juvenile literature 2. Body painting—Juvenile literature [1. Mehndi (Body painting) 2. Body painting] I. Title II. Series
GT2343.W47 1999
391.6—dc21 99—50355
 CIP

Manufactured in the United States of America

Contents

Introduction

Do you feel as if suddenly everyone in the universe has a tattoo? In the last decade of the twentieth century, body art has exploded in popularity just about everywhere. In cities and in underground art scenes, the practice of adorning the body with temporary and permanent art has been the norm for decades. It was not until the mid-nineties, however, that body adornment really took off in mainstream America. Even in the smallest towns, it is not unusual to see teenagers with multiple piercings and colorful tattoos. Did you know that you could experiment with these arts without a lifetime commitment? The fabulous news is that temporary body art is painless, unlike real tattooing, and your parents will be more likely to approve of it because it does not last forever. Real tattoos can be

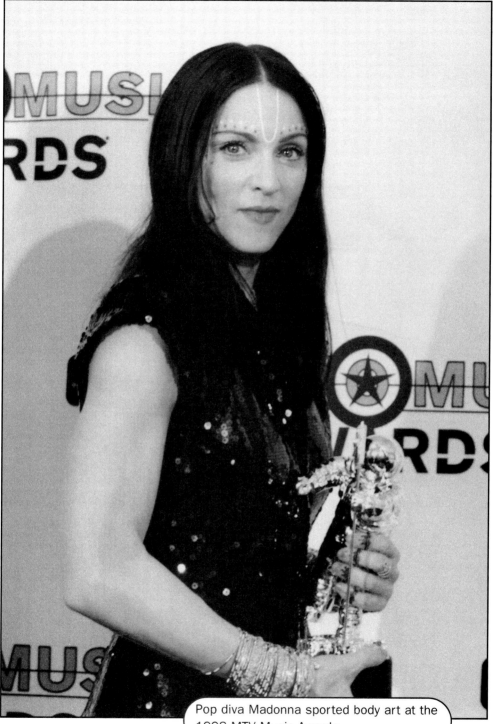

Pop diva Madonna sported body art at the 1998 MTV Music Awards.

removed only with painful laser surgery. What if your taste in art changes even a little bit a few years after you get your tattoo? There is no turning back.

For thousands of years, the women of Asia and Africa have been practicing the ancient art of henna painting, or *mehndi* (pronounced men-dee). The leaves of the henna plant are crushed and made into a paste that is painted on the skin. Intricate patterns and symbolic designs are applied to various parts of the body. (You may have seen Madonna wearing henna designs all over her hands and feet in one of her videos.) But mehndi is a ritual with deep significance for the people of the East, not just a fad. It is a spiritual practice used by people of Hindu, Muslim, and Sephardic descent. (In this book we will concentrate on mehndi from India and Morocco.) You can try out mehndi yourself for fun, and you can create your own rituals as you paint yourself and your friends. All the body arts are a means to self-expression and creativity.

Traditional mehndi is a complex and involved body art. It takes time and patience to learn, and there are many tools necessary to do it right. There are also other ways to create instant mehndi on your body, without taking too much time and making a big mess.

If you are interested in learning about the history and rituals of mehndi, you will find a solid introduction to it in this book. We will go over the basics of it, show you how to do it yourself the traditional way, tell you

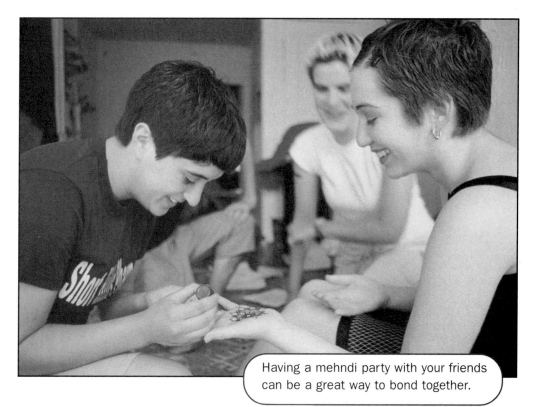

Having a mehndi party with your friends can be a great way to bond together.

where to get the materials, and teach you some designs. At the back of this book, you will find a directory of the resources you need for materials and further reading on the subject. The last chapter will be devoted to other temporary body arts. Let the adornment begin!

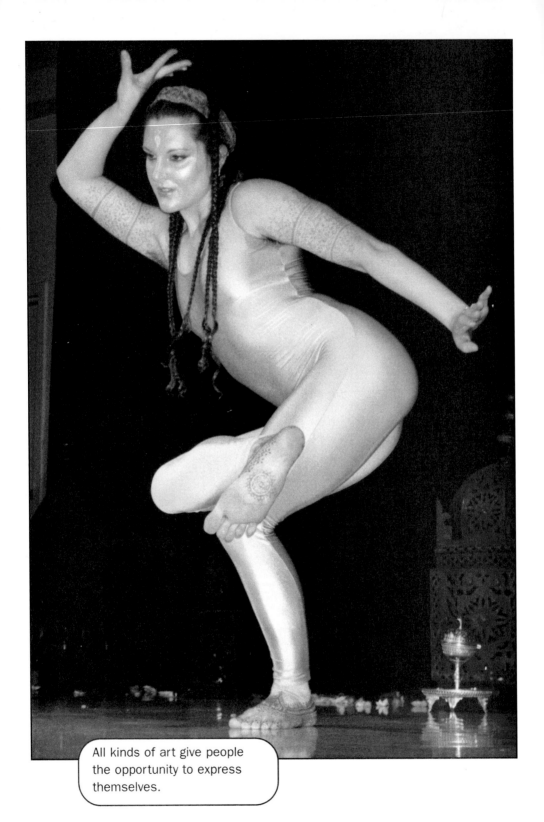

All kinds of art give people the opportunity to express themselves.

Chapter One

The History of Henna

Art is an instinct. Human beings have painted their dwellings and their bodies since the beginning of time. Archaeologists have discovered cave art in areas where the first humans were known to have lived. Cave people told their stories on the insides of their homes with pictures, before there was an oral or written tradition.

Henna is so ancient that it is hard to say exactly when and where it comes from. Many cultures have practiced it. Henna artists use symbols to tell their stories. A symbol is a representation of a greater idea or concept. Symbols are substitutes for language. So the art of mehndi is a kind of language, too.

The Spirit of Mehndi

Mehndi is a spiritual practice. In the West, most people do not think of getting tattoos or putting on jewelry as a way to get closer to God. We put on makeup and wear certain colors because we want to be attractive and fit in with the people around us. In India and other areas where mehndi is practiced, adornment is as important as prayer. In fact, it is a form of prayer. Special symbols are painted on the body to invoke certain gods and goddesses. There are symbols of protection and symbols of good fortune. Sometimes women will have a henna party if they want to influence future events. In Morocco, a religion called animism is a large part of the culture. Devotees of animism believe that many objects contain *baraka,* or mystical power. The henna plant was thought to be the prophet Mohammed's favorite flower, so it is believed to have a high degree of *baraka.* Therefore, some Moroccan women still use mehndi as a magical tool.

Mehndi is also linked to superstition. The deepness of the stain left on the skin of a bride is thought to indicate the strength of the bond between husband and wife. Hindus believe that the goddess Lakshmi exists in henna designs. Lakshmi is the goddess of prosperity.

Women and Mehndi

Mehndi is considered a woman's art. (Although men are

12

often painted and practice mehndi, too. As more Westerners begin to practice the art, this trend will continue.) Historically, it has most often been painted on the hands and feet of women about to be married. The word *shringar,* an Hindu term, refers to the beauty of a woman's creativity. Mehndi is one of the ways that Indian women express their shringar. Women have traditionally used mehndi as a means to celebrate life. In America, we bake cakes and buy cards to mark special occasions. Mehndi designs are unique reminders of important occasions and last for up to two weeks!

No one really knows where mehndi originated. Some people think it started in ancient Egypt. Egyptians were known to dye their fingertips with henna. It was considered impolite to leave one's fingertips unpainted. Some historians believe that the Egyptians may have given the henna plant to the people of India as a gift. It's truly amazing that so little is known about the origins of mehndi, an art that carries with it so much ritualistic and symbolic significance. Mehndi designs are often handed down like powerful family heirlooms. Each design has a meaning, as does the act of painting the design on the skin. The wonder of mehndi, of course, does not end when the henna paste dries. The deepness of the color influences the power of the wish or prayer connected to the wearer. Mehndi reminds us of the cycles of life: It is created, and then it fades away.

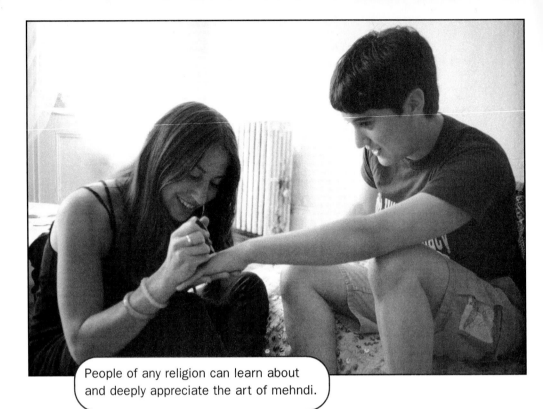

People of any religion can learn about and deeply appreciate the art of mehndi.

There is an interesting connection between the meaning of mehndi and the women who make it and wear it. Women's bodies are deeply connected to the cycles of the earth. The moon waxes and wanes approximately every twenty-eight days, just like the menstrual cycle of a woman. Mehndi also has a cycle: It usually wears off in two weeks, about the time between a woman's ovulation and her period. This is very significant: Ovulation is the time when women can metaphorically give birth to creation. (At this time an egg is available to be fertilized.) When a woman's period arrives, it washes away the unused egg, and the cycle begins anew. Maybe this is why women understand henna so well and continue to use

it and teach it to their daughters, sisters, and nieces.

In many societies, including our own, the talents of women were shadowed and suppressed. It was only recently that women began to work outside of the home. Women continue to fight for their rights all over the world. Mehndi has always been a retreat for women, a space where they could safely bond with one another and share secrets. Now that mehndi is super-popular, the secrets of the art are being shared with men. It is a different world now, and women have been allowed to share in some of men's secrets as well. So boys and men can practice and wear mehndi. In spirit, however, henna painting will always be a woman's art.

What about you? Just because you are not a devotee of Hinduism or animism does not mean you cannot deeply appreciate the art of mehndi. As we approach the end of the century, the ritual is expanding to fit new ideas. More and more, kids are unafraid to look different and experiment with new ways of thinking. Think about the subcultures that might already exist in your school. There might be ravers, Deadheads, hippies, punks, cheerleaders, jocks, skaters, and other groups. Most people who are members of a subculture have a particular way of adorning themselves. Punks might wear leather jackets with spikes and T-shirts with their favorite band's name on them. Deadheads and hippies often wear tie-dyed T-shirts and Indian print dresses. Ravers might adorn themselves with really baggy

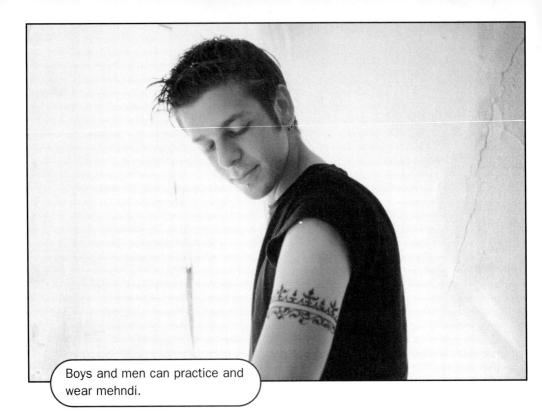

Boys and men can practice and wear mehndi.

jeans and other androgynous attire and might dye their hair in bright colors. What do you think the members of these groups are trying to express with their adornment? How do you express yourself with style?

No matter how you were raised, as a Catholic, Muslim, Jew, Buddhist, or anything else, it is healthy to learn about and experiment with the rituals embraced by other cultures, as long as you are careful not to exploit them. (Some Hindus, in fact, were very disturbed when Madonna performed in traditional Hindi garb complete with bindis and ritual robes at the 1998 MTV Video Music Awards. She chanted in Hindi as well.) As you experiment with mehndi, keep in mind that it is an art with a rich history and a deep significance for the people of the East. It is important to learn

the history and traditions behind these arts as you make them your own. Every art form evolves. Now that henna painting is taking off in America, these people creating new designs are part of the evolution of this art form.

A note to readers: In the following chapters, henna painting will be discussed alternately from the perspective of the painter and the painted. Sometimes that will be the same person. If you are exploring mehndi because you want to create and design for other people, just use the information in this book for your own practice. If you choose not to learn the art of henna painting, and simply want to get painted by someone else, use the book as a guide for what to expect from your experience.

Chapter Two

Making Mehndi

If you have made the decision to experiment with henna painting, there is a lot of planning involved in the process. Keep in mind that practice is essential to the craft, and do not get discouraged if your designs are not perfect at first. Another thing to remember is that if you get really good at mehndi, you might be able to do it professionally someday! Because henna has exploded in popularity, there is a great demand for henna artists in conventional places like beauty parlors. Traditional tattoo parlors now employ henna artists as well. (If you think that you might want to become a professional mehndi artist, you will have to learn business skills in addition to the craft of henna painting.)

It is highly recommended that you first try to find a local henna artist to talk to about mehndi. It is probably a good idea to get some work done by a professional

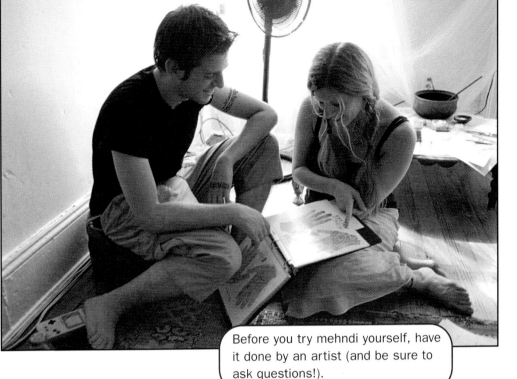

Before you try mehndi yourself, have it done by an artist (and be sure to ask questions!).

mehndi painter before you try it yourself. If there is a henna artist in your community, contact her and inquire about rates and training. Ask how long she has been practicing. Often artists will have a book you can view to check out their work beforehand. Once you feel that the artist is competent, make an appointment.

Do not be shy about using your time with her to ask as many questions as you can think of about mehndi. Ask about local suppliers; ask her to share her recipes if she is willing; ask her what designs her clients like the best. Don't forget to ask the meaning of the design she paints for you. (You can even request a special design.) Once you have had work done by an artist, there is a good chance you will be inspired to do it for

yourself and your friends. Being painted feels great, and when the henna dries, the designs are beautiful and eye-catching. They are definitely conversation pieces! The application of henna is thought to be healing and rejuvenating to the body. Some people say it is like going to a spa. (Maybe that is why the treatment is offered at beauty parlors.) Henna artists report that the work they do makes *them* feel good, too. Most massage therapists and other hands-on healers believe that the healing is a reciprocal act: Giving a massage or painting mehndi heals the practitioner as the work is done.

Common Misconceptions

If you have never seen henna work in person, you might be a little confused by the photos in this book. When henna is first painted on the body, the paste is thick, moist, and dark. After the henna paste dries and is treated with lemon sugar, it is left on the body for as long as the wearer can leave it on so that the design will take. The scent of henna will remain on the skin as long as the dark paste is left on. Then the dried henna is scraped off, and the henna tattoo left on the skin is visible. The skin is actually dyed by the henna paste. The longer you can leave the paste on, the darker the design will be. The color of the henna will be in the red family, anywhere from orange to sienna to deeper reds. This depends on skin tone, where on the body you have cho-

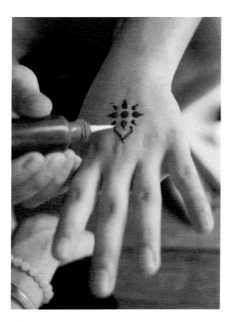

Apply henna

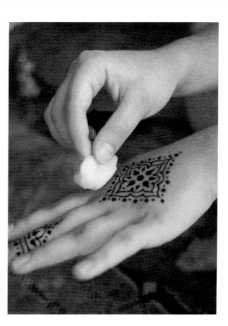

Treat with lemon sugar

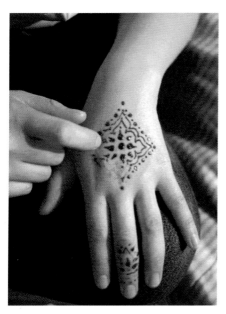

Scrape off henna

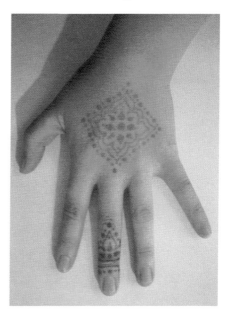

Enjoy

There are four basic steps to doing mehndi painting.

sen to be painted, the quality of the henna, and the amount of time the dried paste is left on the skin. Notice the differences between the prescraped and post-scraped mehndi photos in the book.

If you cannot find a henna artist in your hometown, you will have to do the legwork yourself. The first step is finding a good supplier of henna products. This is not as easy as it sounds. Although the popularity of henna has increased the availability of henna products, you should be aware that there are many products of inferior quality lurking about. No matter where you purchase your henna, make absolutely sure that you are not buying henna meant for the hair. First of all, this kind of henna will not take on the skin, and second, it might be full of harmful additives. So be careful.

The best place to find quality henna is in an ethnic store: Indian, Moroccan, Middle Eastern, or Islamic. Look in the Yellow Pages for locations. If you know people of Middle Eastern or Indian heritage, you might ask them if they know where to find these specialty shops. Many towns and cities have sections where certain ethnic groups congregate, and these areas can be great places to find materials for henna painting. Shops like this are often magical places, filled with the scent of exotic herbs and spices. These stores can make you feel as if you are in a foreign country. Take a moment to notice the details. This is the beginning of your journey into mehndi, and even the shopping part shouldn't be taken for granted.

The best place to find quality henna is in an ethnic store: Look in the Yellow Pages for locations.

Another thing to watch out for when shopping is the label "black henna." Real henna is never black. It just appears black before it has been scraped from the skin. Since henna has grown so trendy, many black henna products have been made available commercially. These products are not real henna. True henna will be anywhere from green to brown in raw form. On the skin, after the paste has been scraped off, the designs will be in the red family. The color will vary from person to person and from one body part to another. Henna should have a deep and fragrant smell, like fresh herbs. If your nostrils detect anything that seems artificial or chemically based in the henna powder, do not buy it. A lot of the henna currently available is chemically

23

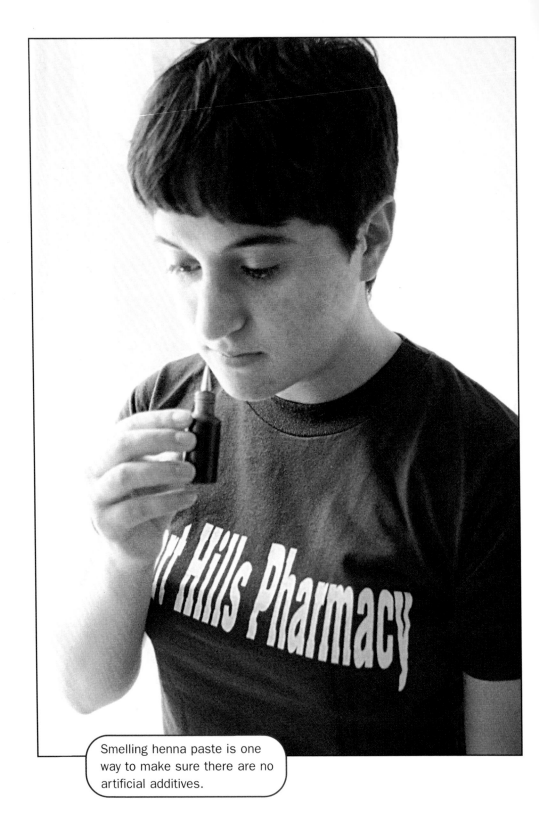

Smelling henna paste is one way to make sure there are no artificial additives.

treated. It will not always say so on the package.

If you are committed to practicing authentic henna art, you can rely on the distributors listed in the Where to Go for Help section at the end of this book to provide you with natural henna. Usually the type of henna in chain stores at malls is the unnatural variety. In chapter five we will discuss the merits and drawbacks of using instant, artificial "henna" products.

Another option is to buy premade paste. If you know a local henna artist who is willing to do this for you, you need to do your painting within a few days because real henna paste is perishable. Ask the artist not to use any additives in the mix. Beware of buying premade paste from commercial distributors because they are certain to contain chemical preservatives. Premade paste is a great option if you want to get right to creating designs. (Designs are in the next chapter.) If you have access to premade paste, much of the information about buying and working with henna powder does not apply to you right now, but you might want to read it just for fun.

If you find top quality henna powder, all you really need to make a paste is the powder and water. Sometimes people use unusual ingredients in their recipes. You can experiment with this if you want to, but we are going to present only simple recipes here. When your work gets more sophisticated, some of the ingredients you might buy include eucalyptus oil, mustard oil, cloves, okra, tamarind, garlic, pepper, orange-blossom

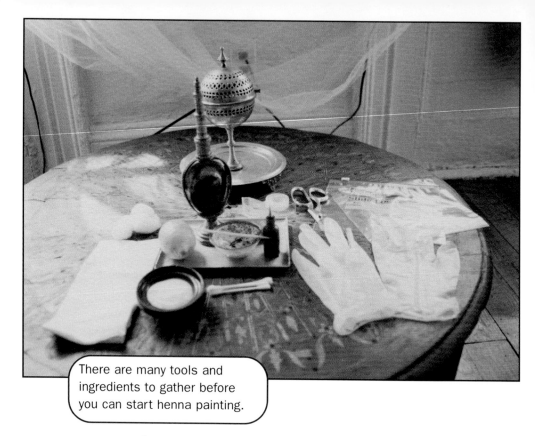

There are many tools and ingredients to gather before you can start henna painting.

water, cardamom, ground black walnut hulls, fenugreek seeds, pomegranate, and limes. These are some exotic additions to enhance the basic henna recipe.

Basic Tools

Next you will need to get some tools. The most important tool is the applicator. Loretta Roome, author of the wonderful book *Mehndi: The Timeless Art of Henna Painting,* recommends the Jacquard bottle for this purpose. The bottles are available at most art stores, usually in the craft section. Just ask someone at the store. If you cannot find them locally, you can order them from a distributor listed at the end of this book.

You will also need heavy-duty, four-millimeter plastic to make cones to fill the applicators with henna paste. Drop cloth or freezer bags work best. Other items you will need are scotch tape; scissors; a ceramic, glass, or wooden bowl; a tea strainer; cotton swabs (get real 100 percent cotton); paper towels; a sifter (if you need to sift the henna powder); flat toothpicks; rubber gloves; and finally lemons and sugar. You might want to get a lemon squeezer too. There are some other fun items that are not necessary, but you might want to get them down the road a bit. They include: coal, incense, porcupine quills, coins, and candles. These are mood-enhancing, Middle Eastern toys for henna time.

Making Cones

Cones are very important. Middle Eastern women often paint with cones. You will need them to fill the Jacquard bottles with henna paste. A mehndi cone is really just a small plastic funnel. It looks like a small pastry bag. To make a cone, cut a rectangle out of plastic (from a freezer bag or drop cloth) about five by seven inches. Cut the corner of one side to make a rounded edge. Roll the plastic into the shape of funnel, with the rounded edge at the tip. The tip should be no bigger than a pinhole. Next tape the seam, and reinforce the tip with tape. Once you have made your paste, you will drop it into the cone with a spoon. (See diagram.)

Cones

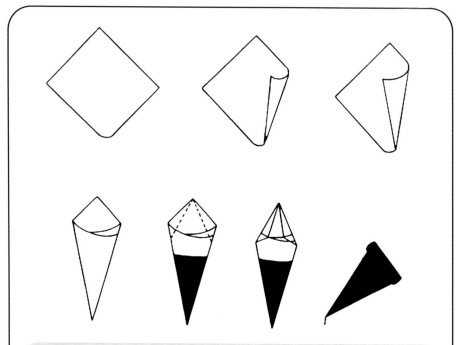

This is a diagram for making cones. Start with heavy duty plastic, such as a piece of drop cloth or a plastic freezer bag. Cut a 5" x 7" rectangle out of the plastic and round out one of the corners. Next, roll the plastic into a funnel shape, making sure that the tip is only about the size of a pinhole. Tape the seam shut along the side of the funnel and around the tip of the cone. Fill the cone about halfway with henna paste.

To seal the cone, fold the corners down as if you were giftwrapping a box. Keep folding the corners down over again until the cone is sealed tight. Tape down all the seams carefully to prevent leaking when you squeese the cone.

That's it! If the hole in the tip is too small for henna paste to pass through, you can widen it using a pin. Likewise, if you want to store the cone to use later, push a pin into the tip to seal it up and keep the henna from drying out.

To Sift or Not to Sift

Unless you are buying presifted powder, you will have to spend a lot of time sifting your henna powder before you make it into paste. This is because twigs and other debris need to be removed before the henna paste will fit through the applicator. Sifting takes a long time; try searching for presifted powder. Some sources of good presifted powder are listed at the end of the book. You can also ask a local henna artist. Do not buy henna in bulk until you have tested it first. It would be a shame to waste money on henna that failed to leave a design on the skin, and it would be really awful to spend time sifting and making paste for no reason. So buy small amounts and test first. You can tell right away that henna has not been sifted if you see twigs in the powder. Presifted powder is more expensive, but the convenience is worth it, especially for the new henna artist.

Even if the package says the henna powder is presifted, it is always a good idea to double-check. Presifted powder will be as fine as baby powder and free of twigs and other debris. You can check powder that you are not sure about by making a small bit of paste and filling a Jacquard bottle with it. (See the section on making cones to do so.) Just mix the powder with a little water to make the paste. If the paste passes easily through the tip of the bottle, it has already been sifted. If there is any clogging, you will need to sift it

yourself. Sifting is a time-consuming process. You can use a nylon stocking and stretch it over a bowl to do your sifting. You basically need to push the powder through the stocking and into the bowl. This should remove any unwanted particles. Now you are almost ready to make paste.

Cooking Time

As mentioned earlier, henna recipes are precious to the artists who create them. If you become friends with your local henna artist, she might share a special recipe with you. We are going to keep it pretty basic in this book. Remember, though, that one of the best things about working with henna is that you have creative license. Feel free to experiment with essential oils and spices and whatever cool ingredients you find on the shelves of the store. Just be careful of synthetic ingredients.

The first time you make a batch of paste, expect to make mistakes. It might take a while to get the right ratio of henna to water. Keep trying, be patient, and have fun! Give your work your full attention. Do not watch television or talk on the phone as you make mehndi. Make sure that you have ample room, and spread newspapers out before you begin. The work can get messy. Put on your rubber gloves if you do not want your hands to stain. Wear old clothes that you do not really care about.

When making henna paste, be sure to give your work your full attention.

The simplest recipe calls for just henna and hot water. Do not boil the water; just make sure that it is very hot. You can also mix the henna powder with pure lemon juice. This is an African recipe. Roome suggests leaving the lemons in the sun for twelve hours before mixing. This is one recipe using half a cup of henna:

- Boil half a cup of dark tea leaves in four cups of water. Keep boiling until half the water is gone.

- Add cloves, dried limes or lemons, or even instant coffee to the brew. (This is optional.)

- Cover the pot and let it simmer for a while. Let it cool overnight.

- When you are ready to make your paste, pour the tea water into a bowl, being careful not to let the solid matter at the bottom of the pot pour out. First squeeze out any large particles with your hands, and then pour the mixture through a fine strainer.

- Add the juice of one lemon, straining out the seeds and pulp.

- Put your henna powder in a separate bowl, and have two plastic spoons ready.

- Use one spoon to add the powder to the brew

while stirring the mixture with the other hand.

• When the consistency feels like cake frosting, stir out all the lumps and air pockets. (Just like mixing cake batter. But don't eat it!)

• Add two teaspoons of eucalyptus oil to the mixture and stir again.

• Test the thickness by holding a spoon of the mixture above the bowl. It should drip slowly like molasses. It should be like a thick lotion or warm hot fudge, according to Roome.

• The henna should sit in a warm place for two hours. Stir it often or cover it with plastic wrap. If it gets runny, you will have to add more powder. It will stay for about two days. Do not refrigerate it. Make sure it is stored safely away from babies and pets.

Now you are ready to paint! The batch will yield enough paste to do one elaborate pair of hands or feet, or about twenty simple bracelets. Heat helps the designs take. Carefully hold the painted part of the body near a heat source, like a candle flame. This is more difficult for larger areas of the body.

Lemon Sugar

Lemon sugar is applied to the design once the henna dries. It prevents the henna from flaking off, although it sounds like a delicious summer treat! It should be prepared just prior to painting. Roome suggests two teaspoons of sugar for every half a lemon. Make sure to strain the lemon juice before you mix it with the sugar. Simply mix it together. The lemon sugar is dabbed on with a cotton ball.

Allergies

It is vital that you test the skin for allergies before painting henna art on anyone's body. Most people are not allergic to the henna itself, but some folks are allergic to other ingredients. Test small areas by mixing a bit of powder with water and letting it sit for about an hour. Then test for richness of color and allergies by dabbing a bit of the mixture on the sole of the foot of the person you will be painting. Once it dries, scrape it off. If the person has an allergic reaction or if you think the color is too light, get different powder and start over.

Prepping the Skin

Many women exfoliate the night before getting mehndi. You can use a loofah to do this. It is also suggested that

you shave or wax the area you intend to paint (if it is a hairy area). Hair removal is not a necessity; it is just that the henna sometimes stains better on hairless skin. It is also important to moisturize the area very well. Do this about a week in advance of being painted, but not on the same day you are being painted.

Beyond prepping your skin, you will have to make some other arrangements before being painted with henna. If you plan to be painted on the insides of your hands, you can forget about using them for much of anything until after you have scraped off the dried paste. Many Eastern women actually fast the night before being painted so they will not have to use the bathroom. You do not need to go to that extreme, but if you plan to get henna on the palms of your hands, make sure that you will not be driving, cutting up food, washing dishes, or whatever else you usually do with your hands. It helps if you treat the time you have henna on your hands as a short vacation. Think of it as time for you and only you. It also helps to have a person you are really close with around to assist you, like a boyfriend, a sister, or your mom. The next time, they can get henna painted on them and receive royal treatment from you!

Don't forget that you can paint yourself, too! You can either paint one hand at a time or paint your feet. It is a little tricky to do this, but it gets easier with practice. Most people think mehndi is more fun when it is shared.

Chapter Three

Symbol and Design

Many contemporary mehndi artists are already visual artists when they discover henna painting. Even if you do not paint or draw, that should not stop you from experimenting with henna design. Let your creative spirit soar. This is a time to get in touch with your intuition. Perhaps you or the person you are painting will want a traditional design for luck or romance. If you become an expert at designing the symbols on the following pages, you can grant the wishes of people who want traditional mehndi designs on their skin. If the person you are painting does not have a particular request, look at him or her and ask questions. Find out why this person wants to be painted. What do you think he or she needs? Play with shapes and lines. Remember when you were in nursery school and the teacher let you finger

paint? It felt pretty free, did not it? Try to feel that freedom again as you paint with henna. That does not mean that you should smear the paste haphazardly, of course. You should be careful and meticulous. But don't let yourself be held back by convention. You are part of the new generation of henna artists, and the designs you create will be part of the lexicon of designs that painters of the next generation will look at and learn from.

Ancient Symbols of India

There is a great deal to be learned from the ancient designs that have been passed down from generation to generation by the women of the East. One of the incredible things that you will discover as you look at the symbols of various cultures is that human beings seem to share a secret language of symbols, even if our oral and written language is very different. The unconscious meanings of symbols that you may encounter every day are often hidden in mehndi designs. Scientists have studied many of the symbols of ancient India and Egypt. They have found, for instance, that some of these symbols resemble fractal geometry and the shapes of cells of the body. There were no microscopes in ancient times, but perhaps the makers of mehndi intuitively knew what they were painting.

There are certain basic forms that you should know before you move into the more complex designs.

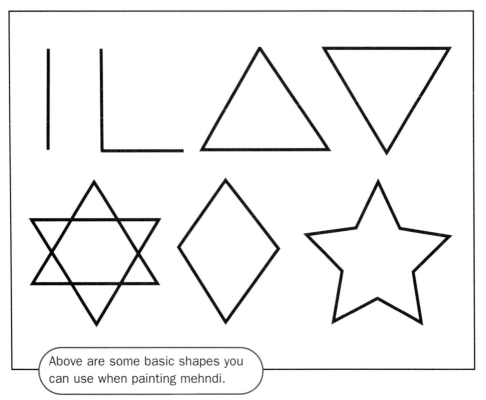

Above are some basic shapes you can use when painting mehndi.

According to the texts of ancient India, all reality grows from the *bija* (kernel or seed). Have you seen Indian women wearing *bindis?* They are small jewels or dots of makeup worn in the center of the forehead to symbolize the opening of the third eye. (They have grown supertrendy over the past few years in the United States. In a later chapter, we will look at bindis as an example of temporary body art.) The *bindu* is a point of Supreme Reality for Hindus. It is the place where everything begins and ends. You will always start your designs from the bija. That just means you are starting from the beginning. Some of the basic forms you will use are the line (*rekha*) and the angle (*kona*). The angle is simply the joining of two straight lines. Once you have mastered painting a straight line

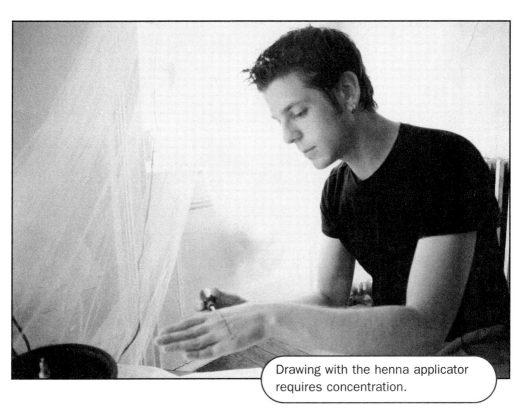

Drawing with the henna applicator requires concentration.

with the applicator (which is not as easy as expert henna painters make it look), you can begin making some geometric shapes rich in meaning. The first is the *trikona*, or triangle. A triangle with its point facing north is connected to the male principle, or *Shiva*. A downward pointing triangle indicates the female principle, or *Shakti*. The joining of these two symbols becomes the *satkona,* or the six-pointed star. This symbol resembles the Jewish Star of David. It symbolizes the merging of masculine and feminine energies. It is connected also to Lakshmi, the goddess of prosperity. The diamond *(vajra)* symbolizes enlightenment. The pentagram, or five-pointed star, symbolizes fire, water, earth, air, and the heavens. Pentagrams are worn by some people as symbols of protection.

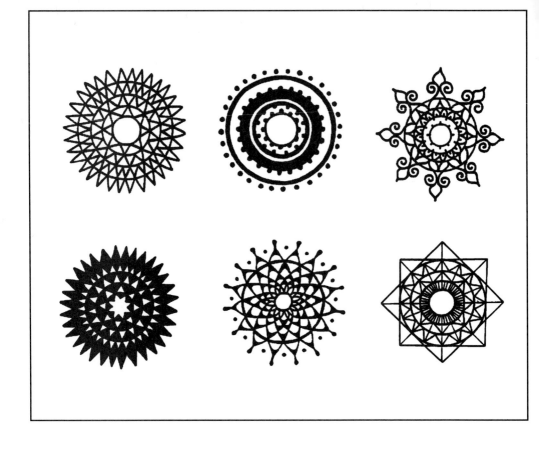

Understanding the Mandala

A famous Swiss psychologist named Carl Jung (pronounced yoong) explored the concept of the mandala in depth. A mandala is an image of form within form. Often it is shaped like a circle, but it can be any shape. Mandalas have concentric patterns that relate back to a center point. In ancient India, a form of mandala called the *yantra* was used by yogis as a tool for meditation. Jung used the mandala as a tool in psychotherapeutic practice. Many henna painters use mandalas in their work.

The Lotus

The lotus is a flower that grows out of the mud or water in and around India. It is the most symbolic form of plant life for many Eastern religions, and it appears over and over again in religious art. It symbolizes the Self rising up through the unconscious, growing from darkness into light. The Hindus associate the lotus with the goddess Lakshmi. The Buddhists see the lotus as a symbol of purity because its petals and leaves 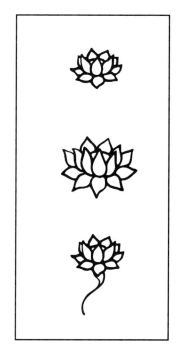 do not show any evidence of the mud from which it grows. It symbolizes life itself. The flower signifies all that grows from the earth, and it has come to mean creativity as well as reproduction.

The lotus is often depicted as an eight-petaled flowers. The outer layers can increase in multiples of four. The petals of the lotus can be round or pointed. You can draw single petals if you choose to. As Loretta Roome says, there is no right or wrong way to paint a lotus. It can float horizontally or hang from a vine. Discover it for yourself as you paint it.

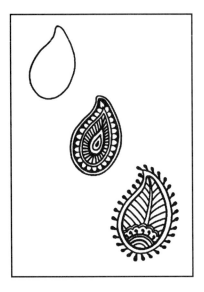

Fruits, Flowers, and Animals

The unripe mango *(keri)* is a symbol of virginity, often used in mehndi painted on new brides. It also symbolizes the coming of summer. Vines are symbols of devotion. You can draw vines around the wrists or on the legs, creeping around as vines do on the sides of homes. Roses, sunflowers, lilies, daisies, and irises are commonly used mehndi images.

Birds are the most commonly used animal motif in the henna art of India. The peacock is the national bird of India. When women are separated from their husbands, the peacock painted in henna symbolizes companionship. Fish symbolize the eyes of women. Scorpions are thought to be like Cupid's arrow; they are romantic images in Hindu mythology.

The symbols of astrology can also be used in mehndi. What sign are you? This is one of the ways that mehndi opens doors to new worlds for the artists that create it. Ideas and images will occur to you intuitively, and then you might want to go back and study them. Artists of all mediums find that they do not always know what they are going to create beforehand. Often they draw,

paint, or write a poem and later realize that their work relates to concepts or ideas that were somehow stored in their unconscious. Jung believed that there is a storehouse of archetypes in the collective unconscious. An archetype is an important idea, concept, or image that reoccurs in our minds (and our various cultures) and helps us to better understand ourselves. Jung also believed that archetypes are shared by people across cultures and through generations. The collective unconscious is a broad term that describes the "place" where the archetypes that we share are stored. It is not really a place, of course, but if you think of it that way it might be easier to understand.

Water is another common symbol in mehndi. Some people believe that water symbolizes the unconscious itself. It also can represent women, the moon, and our emotions. You can paint waves on the skin (*lahariya* designs) or small clusters of dots called *bundakis,* which represent falling rain. They symbolize the love a woman expresses for her husband and in-laws. Lahariya designs represent deep emotion and ecstasy. These designs were often painted on widows who jumped on funeral pyres to die with their husbands. As you create your own designs, you can learn about these images and make them your own. This process of appropriation is used by artists to make new meaning from ancient symbols. Appropriating the lahariya symbol would mean using it to symbolize something positive and something meaningful to

you. Perhaps you are mourning a relationship but know you would never give up your life for a boyfriend or girlfriend. Painting waves on the skin, for you, would mean the opposite of jumping on the funeral pyre of your lost loved one. Instead, it would symbolize the new enriched life you will lead without him or her.

Moroccan Symbols

Moroccan mehndi designs are mainly concerned with protection and fertility. The evil eye is feared by many Mediterranean people, even to this day. An image of the hand, or *khamsa* (pronounced haam-sa), is thought to counteract the effect of the evil eye. Eyes and hands are common motifs in Moroccan mehndi designs and other arts. The eye sometimes appears as a triangle, a diamond, or a dot. Various representations of the eye are thought to act as mirrors that repel the evil eye.

The Number Five

The number five is assigned great significance in Moroccan and Arabic culture. Recitation of the words "five in your eye" *(khamsa fi Ainek)* is thought to metaphorically poke fingers into the evil eye and control it. Saying the word "five" in front of people is taken as an insult because it is viewed as an accusation of wrongdoing. Khamsas, or symbols representing the number five, are hung on doors to protect homes from bad spirits.

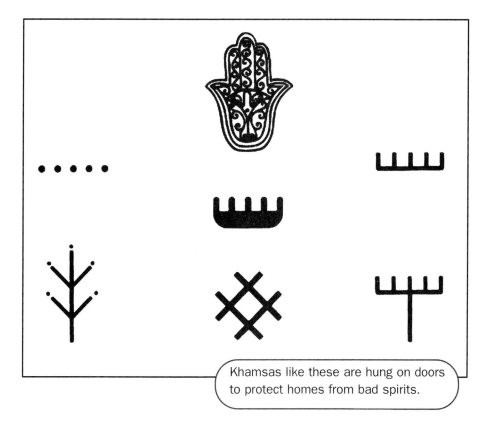

Khamsas like these are hung on doors to protect homes from bad spirits.

Animals are depicted in Moroccan mehndi, often as symbols of protection. The snake represents fertility. The scorpion is drawn very realistically in Morocco and symbolizes protection rather than romance, as it does in India. Of course, as you experiment with your own designs, they will take on new meanings!

When Loretta Roome began her research into the mehndi practiced in northern Africa and India, she was disheartened to find that many of the artists were out of touch with the symbolism of mehndi. She even found that many women considered it old-fashioned and unimportant. When she asked about the symbolism of particular designs, many artists told her that they had no meaning. This may be connected to the

technological revolution and the fast pace of life today. It is precisely because of the increasingly fast pace of our lives that mehndi should be used in the ancient and meditative way it was intended. Mehndi can be a path to knowledge of Self in the midst of the glut of information we are bombarded with every day. Keeping up with e-mail, television, phone calls, faxes, and schoolwork can be overwhelming. That is why yoga and other stress-reducing practices are becoming so popular. The more life speeds up, the more we need to stop, slow down, and give our bodies and minds a rest. Learning the art of mehndi or going out and getting painted by another artist is a meditative practice you can use to relax and remember who you are. New mehndi looks a little different than traditional mehndi, and it takes on a slightly new role in our very new world. Make it yours and use it well.

Chapter Four

Hands and Feet and Other Cool Body Parts

Mehndi is meant to be painted on the palms of the hands. In fact, it stains more deeply there. Think about your hands for a moment. We usually do not stop to appreciate the role they play in our lives. They are there for doing and showing. We use them for mundane tasks, like washing dishes and opening doors, and also for more romantic tasks, like holding hands or writing in our journal. Many women and even men invest time and money on weekly manicures. Our hands are our representatives: They come before us. Mehndi on the palms and the outer hands is a tribute to their power.

The actual act of having mehndi done requires contact between the artist and the person being painted. Energy is exchanged this way, through the hands. This can be very healing for the artist and the client. Mehndi

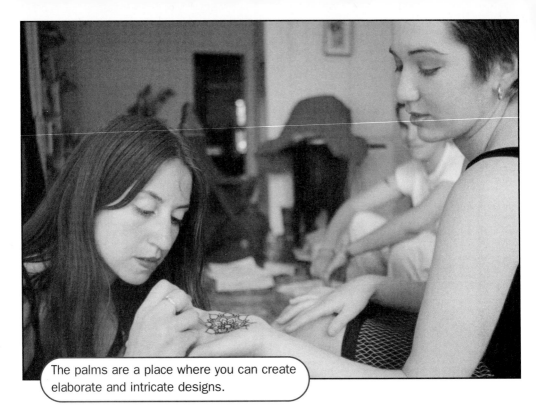

The palms are a place where you can create elaborate and intricate designs.

softens the skin. You must sit still to receive it, which can help to still the mind, and this is the essence of meditation.

In the Egyptian fashion, you can dip your fingertips in henna paste. Egyptian women also painted henna on their nails. (If you do this, it will last for a few months and grow out with your nails.) Think of this as an alternative to nail polish.

Creeping vines are great motifs for the backs of the hands. In India they are known as *b'hai ki bal*. You can even use them to hide skin imperfections like scars. If the skin is dry or tanned, it will be hard for the henna to take. Remember to moisturize and stay out of the sun for a few days beforehand. Roome suggests using Moroccan symbols of protection on the tops of the hands and

images of "opening and offering" on the palms of the hands. She suggests the sun, flowers, or mandalas for the insides of the hands. The palms are a place where you can create elaborate and intricate designs as you experiment and create new worlds. Or you can try to copy some of the more traditional designs.

As you discover yourself and the world through mehndi, you will start to notice some of the connections between the symbolism you encounter and the metaphysical arts. Metaphysics is a branch of philosophy dealing with truth and knowledge that is found outside of objective experience. Some of the occult sciences, like astrology and Tarot, are grouped with the metaphysical arts in bookstores. Palm reading is an example of an ancient Indian science that has resonance for many people but that cannot be proven by modern science. When choosing which hand you would like to be painted with mehndi, consider the traditional qualities attributed to each hand. If you are hoping to add power to parts of your inner life, such as honing your intuition, getting in touch with your emotions, or healing your body, consider having the left hand painted. If you want to do well on a test, get a job, or control some external influence in your life, consider the right hand. For balance, you can always have both hands painted, but total inactivity for at least a day will be necessary if you want the henna to take. Remember to ask someone close to you to help out.

Henna on the Feet

You have probably noticed that the ankles and tops of the feet are a popular location for permanent tattoos. It is traditional in India to have the soles of the feet painted. You may be thinking, now why in the world would I paint my soles? Who would see it but me? Many American brides 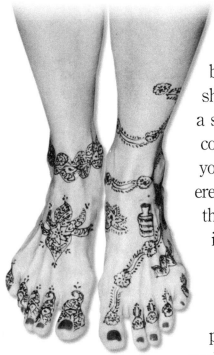 have the soles of their feet painted because they want to share their henna with only their husbands. Body art is not always about showing off. Often, it is about sharing a secret ritual with yourself! (And of course, the henna artist working on you.) One of the problems encountered by those who have the soles of their feet painted, obviously, is walking. A couch, a television, and an intimate friend are important accessories to henna-painted feet. If you can work it out, try getting painted at a location that you can remain at for many hours. Look for a place where you can camp for the night, like your living room couch if it is okay with the rest of your family.

In India, the feet are revered. Here in America, we tend to take our feet for granted. We shove them into high heels and let them sweat in sneakers without a

break. Try to examine your attitude toward feet (yours and other peoples, too). Do they disgust you? A lot of people are afraid of their feet. They like to keep them hidden, and they dread the summer when their feet get exposed in sandals. Other people abuse their feet every day and get a pedicure once in a while to pamper themselves. Henna painting is the most sensual way to experience and love your feet. Think of it: You get to rest with your feet up for at least twelve hours! (That is if you really want the henna to take.) The reason Indian people place importance on the feet is that they view them as the point where our bodies make divine contact with the earth. Americans seem to be far less connected to the earth than people of other cultures, so it makes sense that we would ignore this idea. Try to love your feet. Giving yourself a pedicure is a real treat. Henna is an even better treat, and it is practical too. Henna is cooling, so it refreshes hot, sweaty feet! Use the patterns on the following pages or create your own designs.

Exploring Other Parts of the Body

Henna does not take as well on other parts of the body, but it still looks great. There is a myth that traditional henna is done only on the hands and feet. The ancients used it all over the body as well. Henna lasts longer on the hottest parts of the body. The inner arms stain well, as does the belly. (Lie down on your

51

back for belly application.) Necklaces are a common request by Americans seeking henna painting, but the skin of the neck and collarbone is too thin for the stain to last very long. The back also is not a great place to paint henna if your intention is a dark and lasting stain. The legs can be a good choice, but truly, every-one's skin is different. The thickness of the skin, color, hairiness, and the amount of time the henna paste is left on all make a difference in the amount of time the stain lasts. The less traditional areas of the body, although they do not take as well to henna, are great for experimentation. As a new mehndi artist, this is your territory. Have fun with it.

Chapter Five

Instant Body Art

If you just picked up this book because you wanted to learn more about body art you can buy in the store, this chapter contains some suggestions. Temporary tattoos have been a rising trend in the past few years. You can find them in almost any drugstore. If for some reason you cannot find them in your hometown, contact one of the distributors in the Where to Go for Help section. The World Wide Web is also a great resource for all kinds of temporary body art. Most of it can be ordered on-line. Sometimes the site will list local stores that buy its products.

What exactly is a temporary tattoo? It is really just an image printed on a piece of waxed paper that can be sort of glued to the skin. Usually the skin is dampened and the backing is pulled off of the image. (You might

have to cut it away from other images on the page.) Then it is pressed onto the skin for a few minutes, with gentle pressure from a wet washcloth or paper towel. Then the second backing is removed from the image and voila! Usually temporary tattoos last for a few days to a week, even though the packages tend to say they last from ten days to two weeks. Temporary tattoos come in all shapes, sizes, colors, and designs. The motifs are limitless. There are butterflies, lizards, abstract designs, cats, dogs, cartoon characters, words like "love" or "peace" in bubble letters, astrological symbols, and lots more. If you cannot find what you are looking for at your local store, you can probably find it on the Web.

The cool thing about temporary tattoos, like mehndi, is that you can keep changing your mind about them. Teenagers tend to get into zillions of styles and ideas all in a short period of time. If you do not know who you are yet, how can you know if there even exists a form of permanent adornment that expresses your true self? Temporary body art saves you from having to make a long-term commitment to your current personality.

Bindis have exploded in popularity over the last few years as well. As explained in an earlier chapter, they come from Hindu culture. They are worn in the center of the forehead, between the eyebrows. This area is known as the third eye. Bindis have a sticky backing so that they stay on your face, and come in all colors and shapes.

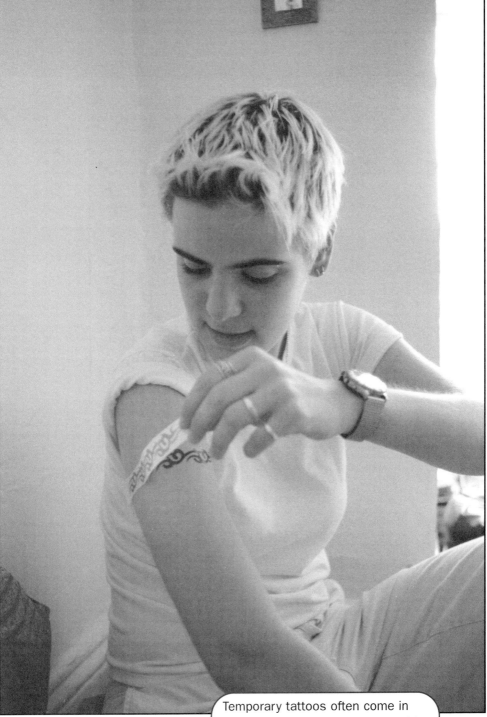

Temporary tattoos often come in designs similar to the ones used in traditional mehndi.

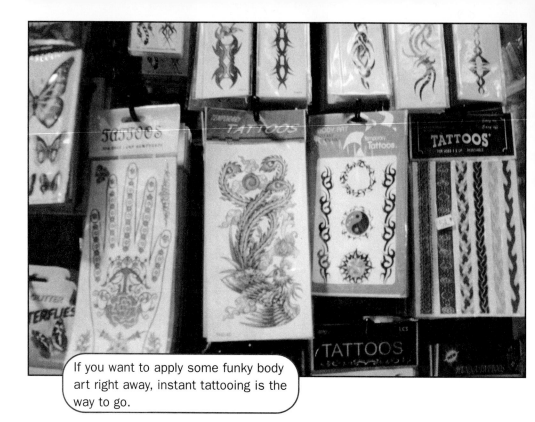

If you want to apply some funky body art right away, instant tattooing is the way to go.

Bindis made in India for traditional wearers are now available in the United States. Sometimes they are made from felt and have a rhinestone. More contemporary bindis are shaped like hearts and bolts of lightning.

Finally, what about instant mehndi? Even though this book has been dedicated to remaking tradition the artistic and arduous way, we will offer some options for mehndi straight from the bottle. There are lots of instant mehndi Web sites. Many of them offer colored henna. Instant henna comes in bottles with stencils, and is sometimes affixed to paper, like the temporary tattoos just described. Just be careful. All of the instant henna products are likely to contain additives. They are not healing to the skin like natural henna. But if you

are going out tonight and you want to look cool with some funky body art, instant tattooing is the way to go.

Although body art has been booming for almost a decade, the thrill of it does not seem to be wearing out at all. In fact, a trip to the local drugstore proves that it is getting hotter and hotter. If you have been thinking about a real, lifelong tattoo, consider testing the waters with temporary body art. (Permanent tattoos are illegal for kids under eighteen without parental consent, anyway.) Remember that as many times as you have changed your mind about what you want to eat for lunch or how much you like your boyfriend or girlfriend, you are likely to change your mind about adorning your body. Mehndi and other temporary body arts celebrate your soul and give your body the freedom to try on new personalities every day.

Glossary

animism One of the religions of Africa, including Morocco.

baraka Mystical power.

bindi A jewel worn on the forehead symbolizing expansion of the consciousness.

cone A funnel made of heavy plastic for use in painting with henna.

henna A Persian name for a small flowering shrub (the Latin name is *Lawsonia intermis*) originally found in Australia, Asia, and on the Mediterranean coast of Africa.

Hinduism The religion of ancient and modern India.

Jacquard bottle A small bottle found in art stores used for henna application.

khamsa An image of the hand thought to offer protection from the evil eye.

Lakshmi The Hindu goddess of prosperity.

lemon sugar A paste applied to the skin after the henna dries.

lotus One of the most common symbols of mehndi. It is a flower thought to represent the duality of nature.

mandala A symbol of the Self. Carl Jung called it the "totality of the psyche in all aspects."

Mehndi The Hindi word used to describe painting with henna on the skin.

metaphysics A branch of philosophy dealing with truths that are found outside of objective experience.

shringar An Indian concept that means the beauty of a woman's creativity.

symbol A thing regarded as representing something else.

Where to Go for Help

The Mehndi Project
(212) 969-8820
This is Loretta Roome's organization in New York.
Many local henna artists are connected to the Project.

Sources for Henna Products

Color Trends
5129 Ballard Avenue NW
Seattle, WA 98107
(206) 789-1065

If you go to a local ethnic store, the following brands are recommended:
Reshma Henna, manufactured by Jawa Exports

Sada Bahar Dulhan Mehndi (Red)

Shelly Mehndi Powder, manufactured by Kaveri Enterprises

For fresh henna paste:
Ziba Beauty Center
18500 South Pioneer Boulevard
Suite 203-204
Artesia, CA 90701
Phone: (562) 402-5131
Fax: (502) 402-2139

For the Jaquard bottle:
Jacquard
Rupert, Gibbon & Spider, Inc.
(800) 442-0455

Web sites

Mehndi (henna) FAQ (frequently asked questions) Web Page: http://www.bioch.ox.ac.uk/~jr/henna/faq.html

Or just type the word "henna" or "mehndi" into your browser's search field.

For Further Reading

Phoenix and Arabeth. *Henna (Mehndi) Body Art Handbook: Complete How-to Guide,* 1997.

Phoenix and Arabeth. *The Secret History of Henna,* 1998.

Roome, Loretta. *Mehndi: The Timeless Art of Henna Painting.* New York: St. Martin's Press, 1998.

The first two books are available by mail only. Send $20 to Phoenix and Arabeth, P.O. Box 304, Ukiah, CA 95482 ($5 extra for overseas shipping), or check them out on-line:

http://www.azpcom.net/phoenix.arabeth.

E-mail Phoenix and Arabeth with questions: phoenix@zapcom.net

Index

Index

About the Author

Stefanie Iris Weiss is a teacher and the author of five books for young adults. She lives in New York City with her cat Caboodle, who also adores body art.

Photo Credits

Cover photo by Karen Tom; p. 7 ©Reuters/Archive Photos; p. 10 and 50 by Stefanie Iris Weiss; all other photographs by Karen Tom.